EVERYTHING IS GOING TO BE OKAY

SIMON & SCHUSTER
New York London Toronto Sydney

a book for you

or someone like you

BRUCE ERIC KAPLAN

SIMON & SCHUSTER
Rockefeller Center
1230 Avenue of the Americas
New York, NY 10020

First Simon & Schuster hardcover edition May 2011

SIMON & SCHUSTER and colophon are registered trademarks
of Simon & Schuster, Inc.

For information about special discounts for bulk purchases,
please contact Simon & Schuster Special Sales at
1-800-456-6798 or business@simonandschuster.com.

Designed by Kim Llewellyn

Manufactured in the United States of America
10 9 8 7 6 5 4 3 2 1

Library of Congress Cataloging-in-Publication Data
Kaplan, Bruce Eric.
Everything is going to be okay : a book for you or someone like you / Bruce Eric Kaplan.
 p. cm.
I. Title.
PN6727.K274E94 2011
741.5'973—dc22 2010047431

ISBN 978-1-4165-5693-0

This book is dedicated to the human race,

who will sit through anything,

especially nowadays.

It was the
end of a
long day, and
Edmund came home and
went to his mailbox filled with hope
as he always did.

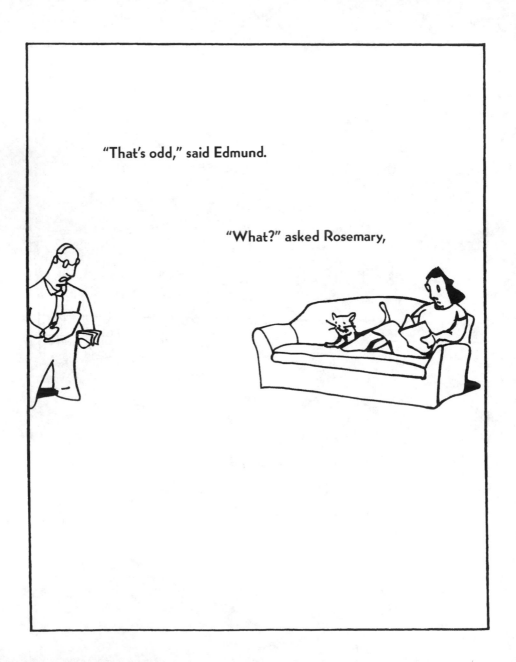

"That's odd," said Edmund.

"What?" asked Rosemary,

who was very involved in the

magazine article she was reading.

How to have the PERFECT

"I've been invited to give the commencement

address at a graduation ceremony

for some small college," he said.

They both wondered why

he'd been asked.

It wasn't because of his career.
Like most people, he just
had one of those jobs
where you didn't do anything,

but it seemed
like you did.

IN OUT

He had never won anything,

nor done anything that would

make him eligible to win something,

not that that stopped him from being

outraged when someone else

won something.

He hadn't been a great humanitarian,

which actually

he was proud

of,

since

everyone

knows great

humanitarians are

usually very mean people.

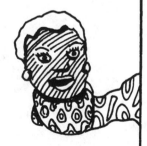

And he had definitely

never been

an African American

Poet Laureate who

favored bright, busy scarves that say

"I am an African American Poet Laureate!"

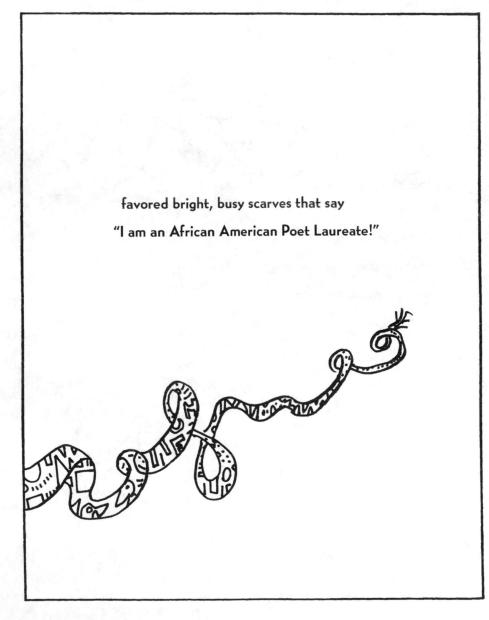

"Well," Rosemary finally said,

"I guess everyone else

was busy."

He excitedly sat down to work on his speech.
Ever since he was a child, he had wanted to
profoundly inspire the next generation.

"Whatever you do," said Rosemary,
"don't tell people they can do anything.
The problem today is that everyone thinks
they can do everything."

Edmund agreed. Even the people
who were supposed to be able to
do things never could.

Edmund wondered if he should talk about the places
people will go. Rosemary reminded him that

it had been done.

"You could always tell them that
love is the answer,"
Rosemary offered tentatively.

"Love *is* the answer,"
Edmund said. "I just
wish it was a more
interesting answer."

"Love is boring," Rosemary
had to admit.

"Hmmm . . ." they both said, stuck.

Suddenly it seemed as if there

was nothing in the world to say.

Rosemary thought about

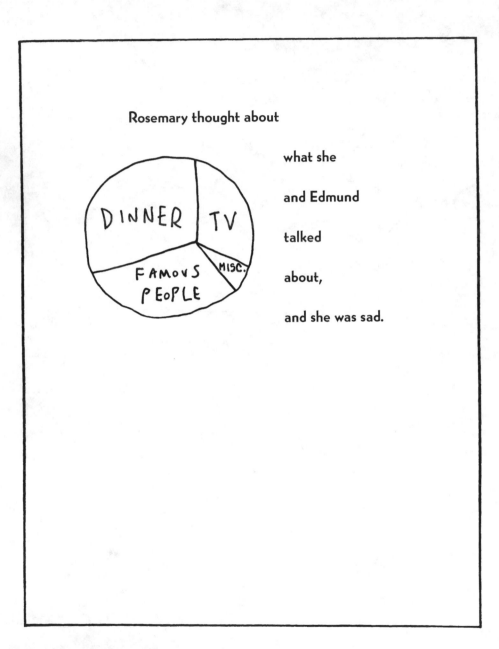

what she

and Edmund

talked

about,

and she was sad.

The next day Edmund

stayed home from work

to write his speech.

Alone, Edmund stared at

the blank page.

There is nothing scarier than

the blank page.

Nothing.

Edmund looked over at Delia in
the corner, judging him as
she always did.

Delia had been working hard
at not being so judgmental
but was nobly failing.

Unable
to come up
with
anything,
Edmund
began
to
clean
the
apartment.

He found areas to clean

he had never found before

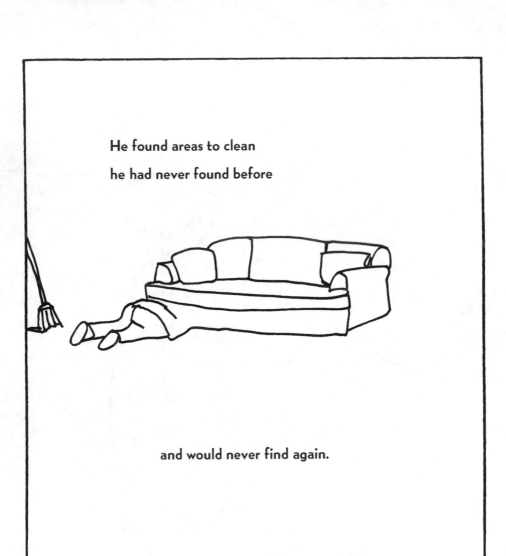

and would never find again.

When Rosemary came home
and saw how clean everything was,
she hugged Edmund
sadly.

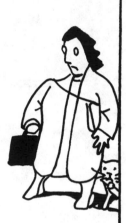

She told him he should get
a fresh start tomorrow.

It was worse than the day before.

Edmund wanted to die.

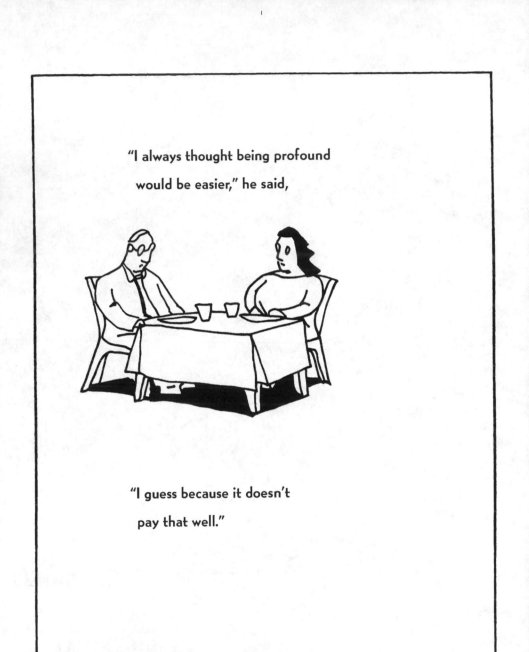

"Come on," Rosemary said. "Just think of something you've learned that you want to pass on."

He said, "The only thing I can think of is that if you are driving and you're lost, you should pull over instead of going really slowly and looking out the window, making life miserable for

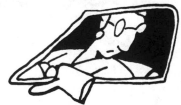

everybody else."

"I think you can do better,"
Rosemary said.

"Maybe the Kabbalah has
something I can use.
Should we study
the Kabbalah?"

"No," said Rosemary
very very very firmly.

"I've been alive for so long," said Edmund.
"I should have some wisdom by now."

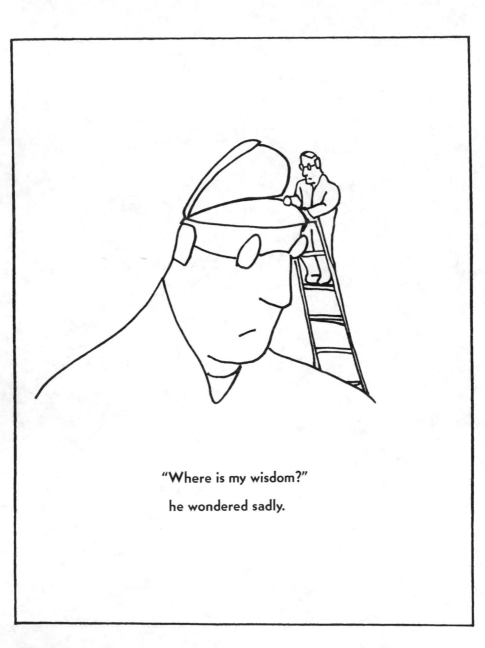

"Where is my wisdom?"

he wondered sadly.

"In the basement!" Rosemary

suddenly said.

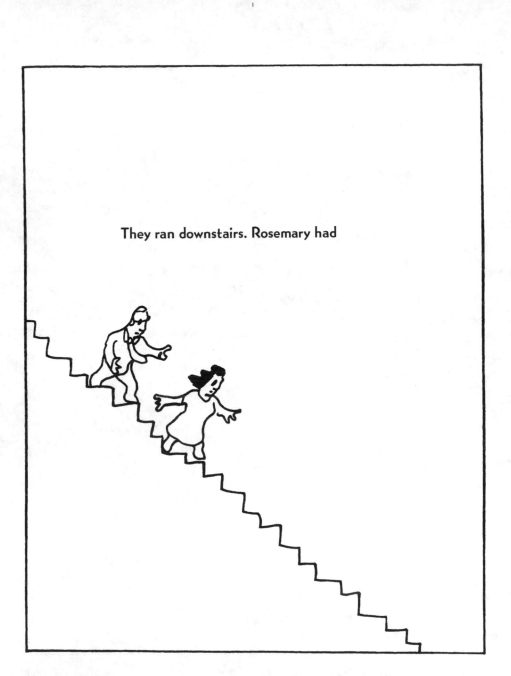

They ran downstairs. Rosemary had

remembered that they had both

started journals and had kept

them on and off for

several years.

They had never really
stuck with it because,
let's face it, it's impossible
to ever stick with something
that's good for you.

There is nothing more depressing

than reading an old journal,

for about eighty million reasons.

"Nope," Edmund finally said.

"No wisdom here."

Edmund and Rosemary

went to bed, dejected.

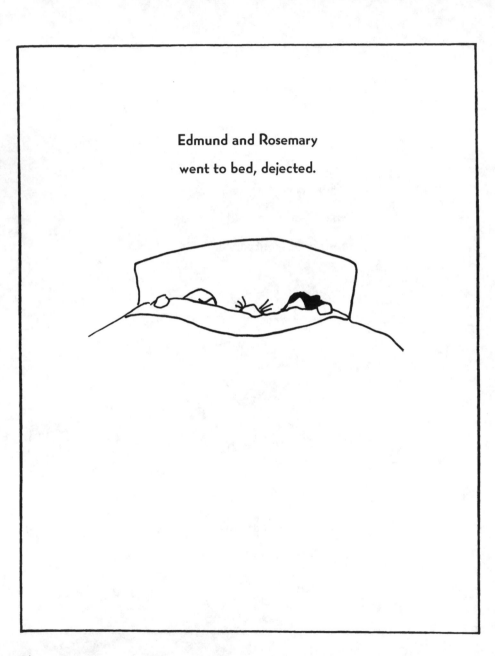

Rosemary woke up anxious. All this talk
of not learning anything had made
her start to question her life.
Was everything she had
ever done a mistake?
But if this were true,
was having this thought
a mistake? In which
case everything she
had done wasn't a mistake.
Rosemary felt better.

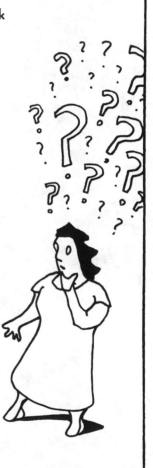

Edmund came in and told her he had come to a decision. He couldn't give the speech. He would call the college immediately. This thing that had been so wonderful was really terrible.

"That's so true," said Rosemary.

"You think something is so great,

but then it is so bad. That

happened to me with those chips

that had Olestra."

"I remember that,"

said Edmund.

He thought for a moment.
"But on the other hand, something
that you think is horrible happens,
and then years later, you look back
and realize something beautiful
came out of whatever you
thought was so bad."

They both looked at Delia,
who had come into their lives
due to a period of much pain
and struggle.

"Maybe this could be my speech,"
Edmund said, but then immediately
began to be plagued by doubts.

Rosemary talked him into
sitting down and just
writing it. Which he did.

Rosemary was a big believer
in just going forward,
which sometimes
doesn't quite
work out,
but for the
most part,
it is a very
important
thing to remember. Maybe it's
because going forward is truly living.

Edmund and Rosemary
woke up early the day
of the graduation
and rushed around
getting ready.

Suddenly it was time to go and they hadn't done anything they needed to do.

They both got tense whenever they needed to actually do something. "In a perfect world," Edmund said, "no one would ever have to do anything."

Delia hid in Rosemary's sweaters. Her mother had been very tense and it was scarring.

The drive up was very pleasant.

The best part about going somewhere

is it feels like you are going somewhere.

They passed a

and Edmund told the same
story he always told about
going to rest areas when he
was a kid and begging his
parents to buy him the

Moo-Cow Creamer,
which they always
had on the tables
and sold in the
gift shops.

"You spend your whole life pining
over crap you don't need that
if you ever did get, you would
just throw out," Edmund said.

They thought about all the

past and future Moo-Cow

Creamers in their lives

as they drove by real cows.

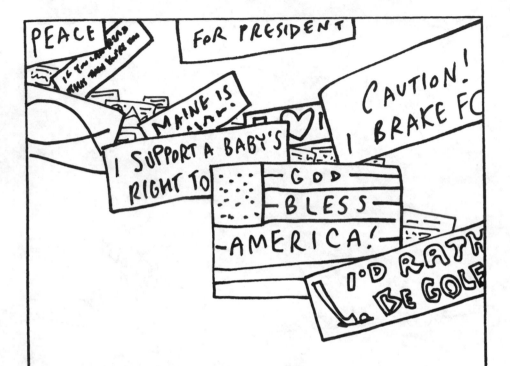

At one point, Edmund and Rosemary
found themselves driving behind a man
in a car covered with bumper stickers.

They wondered what horrible

childhood traumas

could create

an adult who had a car

covered in bumper stickers.

After a while, Rosemary fell

asleep while Edmund

kept getting caught staring

into other people's cars.

Edmund guessed the people
he was looking at got mad
because we all think we are
alone when really we are not
when really we are.

AUNT
PITTYPAT'S
GIFTS -n-
THINGS

Rosemary woke up as they got

off the highway and drove

through an idyllic town full

of quaint stores.

"I would love to own a little shop,"
she said, "as long as I didn't have
to deal with people or worry about
bills or cleaning anything."

"So you just want to sit in
a quaint store," Edmund said.
Rosemary nodded happily.

They reached the campus and saw hundreds
of students walking around with their parents,

barely tolerating them.

Rosemary remembered
her youthful angst
with fondness.

It was so much
more fun
than middle-aged angst.

Edmund drove around and around,

looking for a place to park.

Finally, with joy, he realized

this was one of those situations where

there were no rules and you

could just put your car

anywhere.

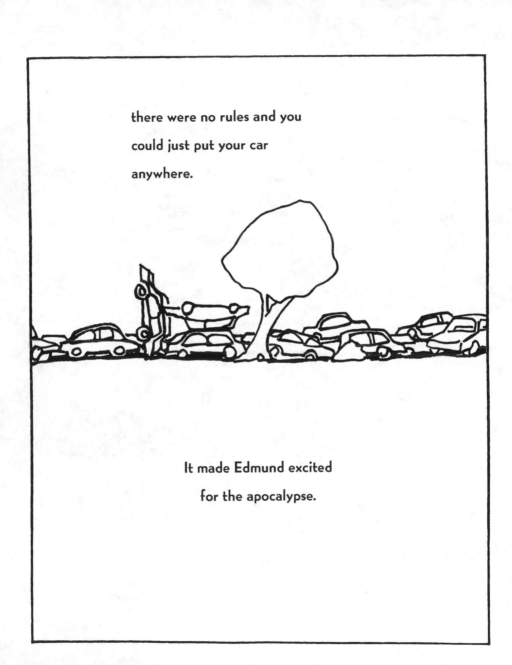

It made Edmund excited

for the apocalypse.

They ran to the football field.

Edmund spent his entire life panicked
about being late for things he
didn't want to do.

Rosemary spent her entire life
reassuring Edmund that nothing
happened when it was supposed to.

Rosemary kept telling

Edmund to wait up for her.

As always, he resented

her shoes.

They took their seats

as the graduates began marching in

all hung over.

The speeches began.

Rosemary didn't listen. She had
never been able to listen to anything
you were supposed to listen to.
She thought, "That's why everyone
loves to eavesdrop. It's much easier
to listen if you aren't supposed to."

Edmund looked at the
faces of the graduates

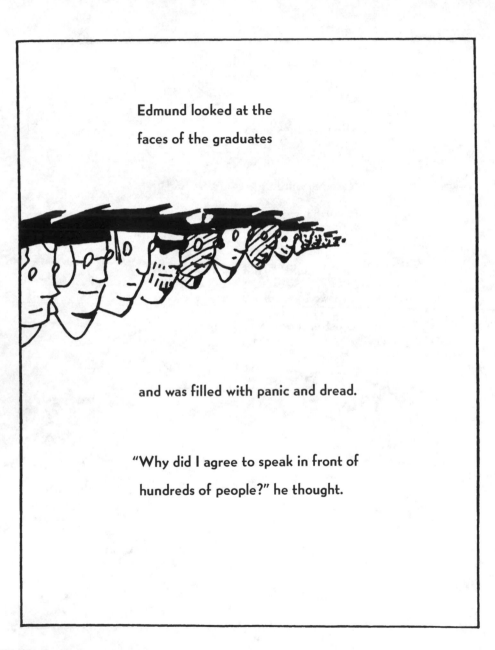

and was filled with panic and dread.

"Why did I agree to speak in front of
hundreds of people?" he thought.

He felt trapped,

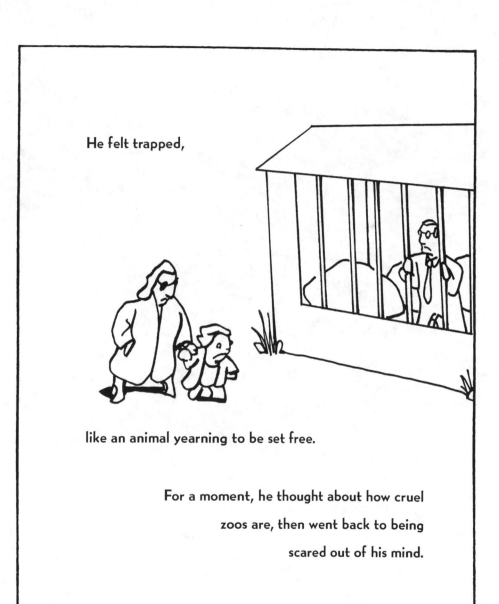

like an animal yearning to be set free.

For a moment, he thought about how cruel
zoos are, then went back to being
scared out of his mind.

As his heart raced, he wished he had something
to make him feel numb. Now he truly knew
why our country was so overmedicated.

He continued deeper and deeper into
his fear until finally, from far away,
he heard his name being called.

He walked to the podium, trembling.

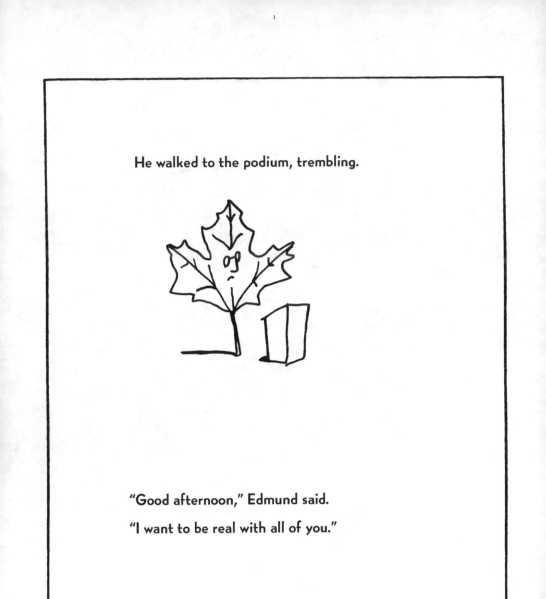

"Good afternoon," Edmund said.

"I want to be real with all of you."

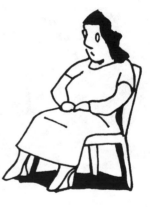

That made Rosemary nervous.

An ex-friend had once begun a conversation with her by saying, "To be perfectly honest . . ." and they never spoke again.

"I was afraid to come up here,"
Edmund said. "But we should
never be afraid of anything.
Oh, except big dogs.

"But other than that, fear is
something that is just created
by our minds. For instance,

none of you are scary. In fact,

you are all beautiful."

Actually there was someone in the

back row who wasn't beautiful

but Edmund didn't acknowledge that.

So in a sense he was being only somewhat real,

which is all anyone can really take.

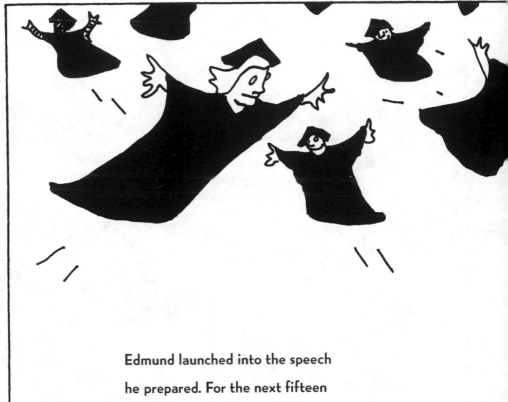

Edmund launched into the speech
he prepared. For the next fifteen
minutes, Edmund was hopeful,
he was funny, he was moving,
he was inspirational.

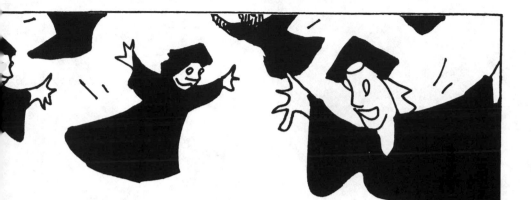

It was the perfect graduation speech.

Then

it kept going.

Edmund wouldn't shut up.

Edmund didn't understand why
he couldn't stop.
All he knew was he just
couldn't.

He quickly exhausted all his
material about good things
being horrible and vice-versa,
so he scrambled to say
anything inspirational
he could think of.

He began by
spouting clichés.

He went through every one he had ever heard,
ending with, "If life gives you lemons,
make lemonade."

That thought had always angered Rosemary.
What if you didn't like lemonade?
She didn't and never had.
She wanted to scream at the graduates,
"Don't make the lemonade!
Go find yourselves a new tree,
one with fruit you really want!"

Edmund reached deep down
into his childhood to remember
a valuable lesson he had
learned when he was
a Boy Scout. It was that
we should all "Be Prepared."

Rosemary wasn't so
sure about this.
She started to
add up all
the time

she spent getting prepared—
to go to work, to come
home, to go out again,
to go to bed.

"Maybe we all spend too much time
preparing and not enough time
just being present," she thought.

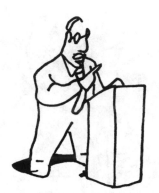

"Be present,"
Edmund said,
as if reading
her mind.

Sadly, no one heard him

because every single audience member

was texting, even the people who

didn't have any devices to text with.

Not knowing anything about the subject, Edmund launched into a lengthy discourse on the importance of good works and leading a life devoted to service.

Rosemary got really bored.
She had a thought she often
had, which was that all our
scientists should be working
on making people less
boring instead of just
being in the pocket
of big business.

Oddly enough, sitting just three rows away from Rosemary, there actually was a scientist who was working on some theories about the physiology of boring people and how to make them more interesting.

But he was a crackpot.

Hours had now passed.

People began to get bored

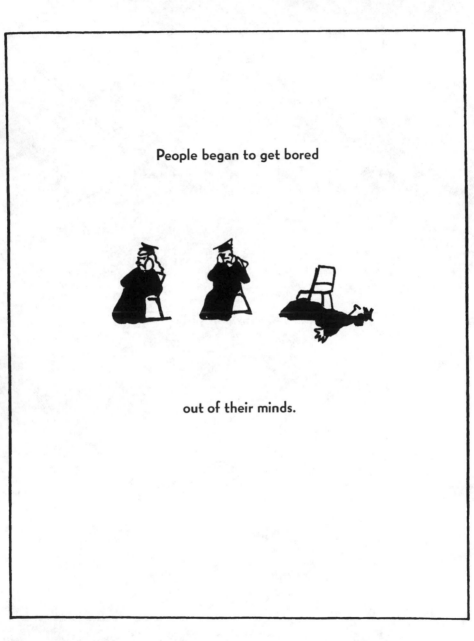

out of their minds.

For some reason, Edmund found himself
telling the Buddhist parable about the
five blind men and the elephant,
wherein each man
had a different
idea of
what an
elephant
is,

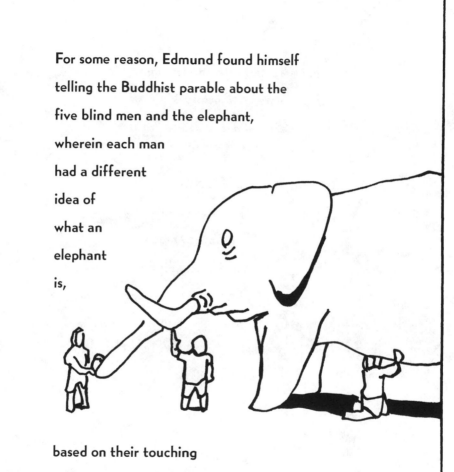

based on their touching
different parts of the elephant.

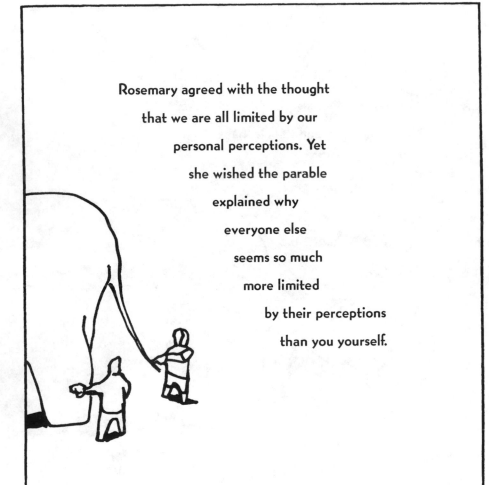

Rosemary agreed with the thought
that we are all limited by our
personal perceptions. Yet
she wished the parable
explained why
everyone else
seems so much
more limited
by their perceptions
than you yourself.

Night fell.

Rosemary, thank God,

had brought a wrap.

Edmund was now telling the story

of the movie *Tootsie*.

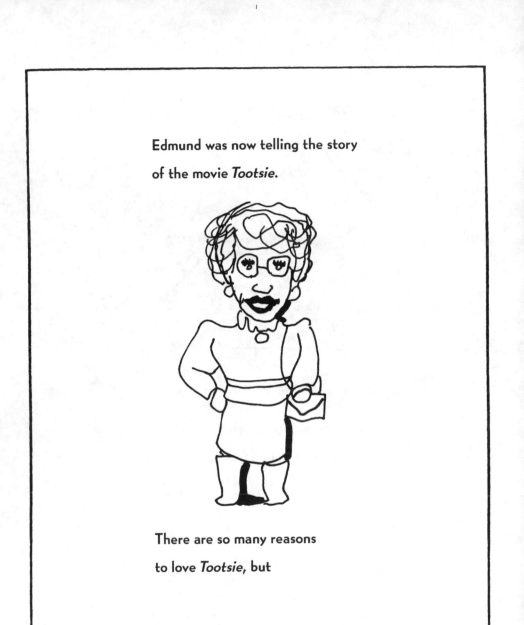

There are so many reasons

to love *Tootsie*, but

two of the best are that it is about
being true to your artistic self, yet
making a living, and it is about
trying to grow past one's own
limitations, which none of us are
doing enough of.

It is a classic. That being said,
as Edmund went on and on
and on, everyone felt they
could have cut ten minutes
from *Tootsie* and it would
have still been a
classic.

Edmund talked all through the night.
Hours before, when Edmund had
admonished the graduates to see more
sunrises, no one had realized that they
would all see the next sunrise, or that they
would all still be together when they did.

More time passed,

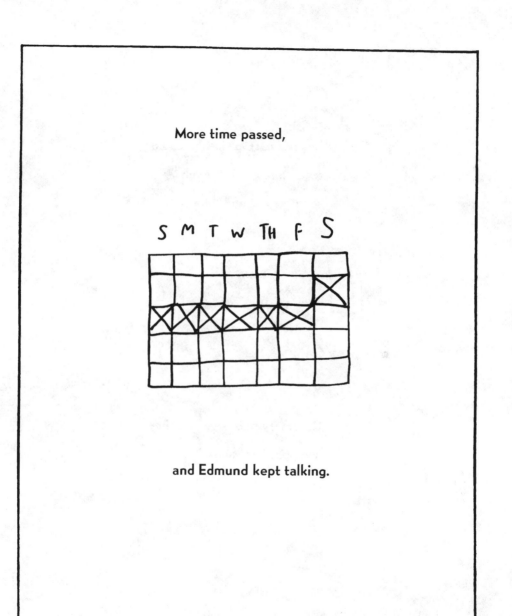

and Edmund kept talking.

It was amazing that he could
go on and on, but really
we all could and do.

Rosemary had been wearing
a supportive smile the
whole time.

Her face hurt.

Edmund talked about how he once
walked past a dance studio
and looked inside and saw
a woman sweeping.

It couldn't have been fun, or
interesting, but she put her
whole self into pushing that
broom. It was very inspiring.

Rosemary could see how much
Edmund had learned from that
one small moment.

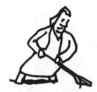

It's amazing how
anything can teach
us something, yet it seems
like nothing teaches us anything.

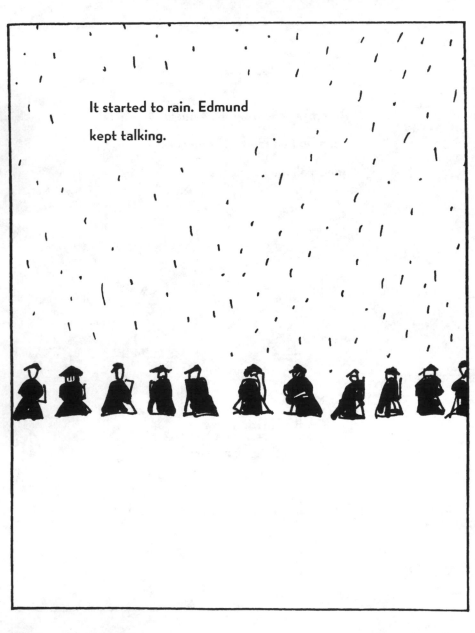

It started to rain. Edmund
kept talking.

Many, many, many stories later,
it started to snow.

Edmund kept talking.

Edmund spent one whole day

 talking about
ham and cheese
sandwiches and
how he used to
love them, but now

he was revolted by them, especially the ones with

Russian dressing. He told the graduates we all have

great passions that may one day disgust us.

Rosemary suddenly wondered if Edmund
was ever going to stop talking,

especially when he digressed
for an hour to talk about how
skimpy the meat was on the
lunch sandwiches his mother
had given him and how this
caused a lot of
shame for him.

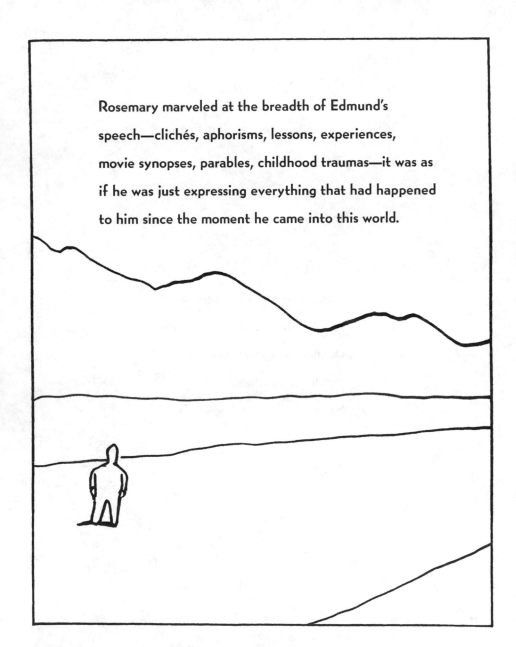

Rosemary marveled at the breadth of Edmund's
speech—clichés, aphorisms, lessons, experiences,
movie synopses, parables, childhood traumas—it was as
if he was just expressing everything that had happened
to him since the moment he came into this world.

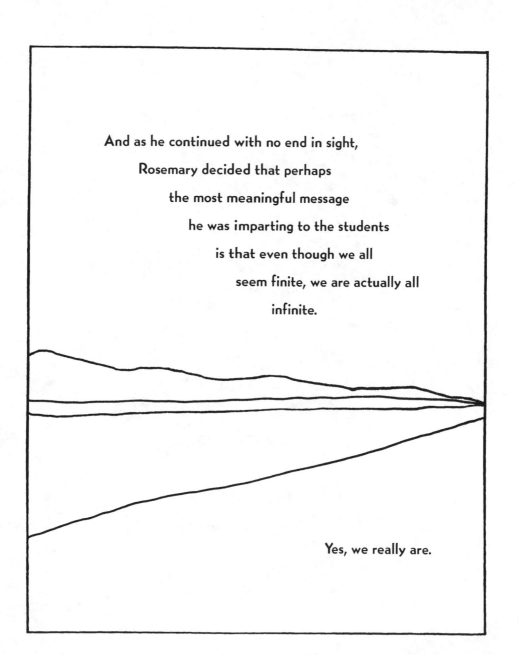

And as he continued with no end in sight,

Rosemary decided that perhaps

the most meaningful message

he was imparting to the students

is that even though we all

seem finite, we are actually all

infinite.

Yes, we really are.

Rosemary studied Edmund. He
looked fragile, almost as if he were
about to break into a million pieces,

as he told the graduates to
surrender and not resist change.

And suddenly Rosemary knew
why Edmund couldn't stop.
He was doing anything he
could to keep the graduates

from going out into the world.
He wanted to protect them from
all the terrible things that
could happen. But he also
knew how foolish he was.
He looked at Rosemary,
begging her with his eyes
to help him stop.

She thought for a
moment, then leapt up.

She ran to the nearest building,

which housed the Art Department.

Like all art departments, it was the

best-smelling place on Earth.

Rosemary hurriedly

made a big sign and

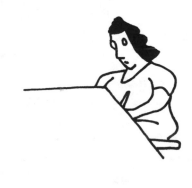

ran back and held it up.

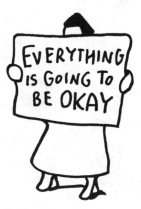

Edmund looked at her and smiled.

"And finally," he said,

"I'd like you all to know that

everything is going to be okay."

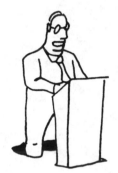

Then he added,

"Even if it isn't."

The speech was over,
the graduates got their
degrees, and the
ceremony ended.
Everyone had been
greatly changed
by the experience.

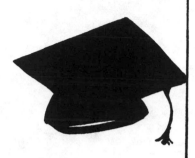

We're always changing even
if we don't know how, even if we
don't want to, and even if we
think we aren't.

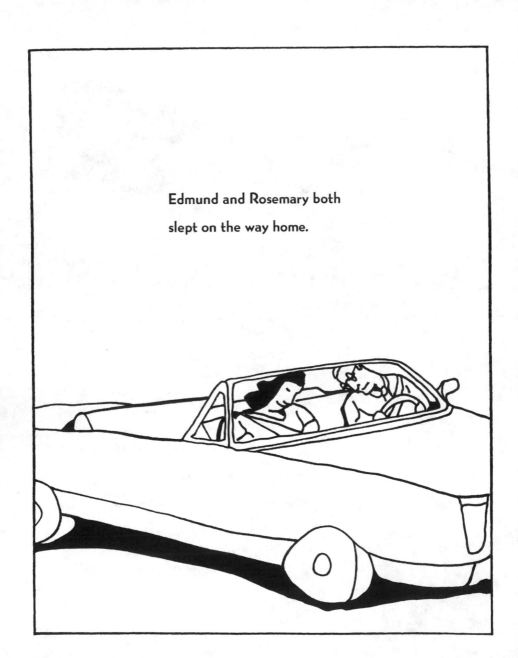

Edmund and Rosemary both
slept on the way home.

When they arrived at their door,

Delia jumped into their arms.

Edmund and Rosemary had never

been gone for that long before.

Thank goodness
they had left out
some extra food for her
in case they were late.

Delia had really grown

because of this time

on her own.

It was nice to

see her

standing

on her own two feet.

And suddenly, in that moment,

all three of them were filled with

the sense of possibility that is

all around us,

because

really

anything is

possible,

ESPECIALLY

the

impossible.